ARTS AND CRAFTS

POTTERY AND CERAMICS

ARTS AND CRAFTS

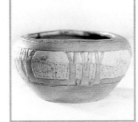

TEXT BY
JOANNA WISSINGER
CONSULTING EDITOR
RAYMOND GROLL

PHOTOGRAPHS BY
MARK SEELEN

POTTERY AND CERAMICS

THE DETAILS SERIES

CHRONICLE BOOKS

SAN FRANCISCO

A Packaged Goods Book

POTTERY AND CERAMICS
was conceived and produced by
Packaged Goods Incorporated
9 Murray Street
New York, NY 10007
A Quarto Company

Library of Congress Cataloging-in-Publication Data
Wissinger, Joanna.
 Pottery and Ceramics / text by Joanna Wissinger: photographs by Mark Seelen.
 p. cm. – (Arts and Crafts)
 Includes bibliographical references (p.) and index.
 ISBN 0-8118-0763-0
 1. Art pottery, American – Catalogs.
 2. Art pottery–20th century–United States–Catalogs.
 3. Arts and crafts movement–United States–Catalogs.
 I. Title. II. Series: Wissinger, Joanna. Arts and crafts.
 NK4008.W57 1994

 738.3' 0973' 0904 – dc20 93-47526
 CIP

Design by Janine Weitenauer
Photo scouting by Margaux King

Distributed in Canada by
Raincoast Books
112 East Third Avenue
Vancouver, B.C. V5T IC8

10 9 8 7 6 5 4 3 2 1

Chronicle Books
275 Fifth Street
San Francisco, California 94103

Color Separations by Eray Scan Pte Ltd.
Printed and bound in Hong Kong by Sing Cheong Printing Co. Ltd.

Acknowledgments

As the author, I would like to thank

Raymond Groll,
our consulting editor, who gave of his time
and expertise without stint; and the following collectors
and dealers, without whose enthusiastic
and generous participation this book would not exist:

Allan Wunsch

Stephen Gray

Catherine Kurland, Lori Zabar, and Shawn Brennan
of Kurland·Zabar Gallery

Barry R. Harwood

Robert Posch

Margaux King,
for scheduling, scouting, and positive attitude

Helen Groll, for her patience

Mary Forsell for editing

and as always, my husband,
Paul Mann

·8·

INTRODUCTION

·13·

THE POTTER'S QUEST

·15·

FROM AN ARTIST'S HANDS

CONTENTS

·17·

SMALL WONDERS

·18·

WELLER XENIA

·19·

POPPIES AND ROSES

·21·

ROSEVILLE MOSTIQUE

·23·

SATURDAY EVENING GIRLS

·24·

ENGLISH LUSTER AND FLAMBÉ

·26·

VASEKRAFT

·29·

MARBLEHEAD

·31·

ONE OF A KIND

·32·

WELLER BY FREDERICK RHEAD

·34·

TECO

·39·

A TALE OF FOUR SISTERS

·41·
DENAURA AND CRYSTAL PATINA

·42·
INDIAN WARE BY CLIFTON, WELLER, OWENS

·45·
ROOKWOOD HAND THROWN

·46·
SPLENDID STONEWARE

·48·
OWENS AQUA VERDE

·51·
VAN BRIGGLE

·52·
DRESSER POTTERY

·54·
BUFFALO POTTERY

·57·
PIPED LIKE ICING

·58·
HAMPSHIRE POTTERY

·60·
SOURCES

·62·
CREDITS

·64·
INDEX

ESTABLISHED IN 1911, NILOAK POTTERY'S DISTINCTIVE WARE WAS CREATED USING SEVERAL COLORS OF LOCAL ARKANSAS CLAY, CREATING A SWIRLING, MARBLEIZED EFFECT. EACH PIECE WAS HAND THROWN. THE NAME COMES FROM THE REVERSE SPELLING OF "KAOLIN," A TYPE OF WHITE CLAY USED FOR FINE PORCELAIN–IRONICALLY, IT WAS NOT USED IN THE MAKING OF NILOAK PIECES.

JUST AS THE GORGEOUS GLAZES AND
pure forms of art pottery enticed the first
Victorian collectors, they continue to in-

INTRODUCTION

trigue us today. Art pottery was perhaps the
most popular facet of the Arts and Crafts
Movement—a decorative arts style that began
in the last quarter of the nineteenth century.
Art pottery also gained momentum during this
last quarter, yet flourished long after the
movement reached its zenith of popularity in
the years prior to World War I.

Science and philosophy both con-
tributed to the fashion for "art"—as opposed to
mere utility—in pottery. Improvements in glaze

formulas and firing techniques lent a new aura of sophistication to the potter's craft in the middle to late nineteenth century. Concurrently, English critics and writers John Ruskin and William Morris set about preaching a new dogma. Distressed by the decline of craftsmanship resulting from machine-produced decorative objects of the Industrial Revolution, they wished to reintroduce the beauty of handwork to these industries and restore respect, purpose, and better labor conditions to the working class. In addition, partly as a reaction to the fussiness of cluttered Victorian parlors, Morris also preached a doctrine of elegant simplicity in home design. He advised that his followers should, "Have nothing in your houses that you do not know to be useful or believe to be beautiful."

Pottery making was a natural place for such a philosophy to take root since it lent itself easily to individual workmanship (indeed, the Arts and Crafts Movement affected the American pottery industry before any other). It was relatively simple to set up a small workshop, with a professional potter to throw the wares and a staff of artists to decorate each piece. Many such participants were women, who were involved in everything from glaze formulation to pot throwing to decoration. In fact, a number of potteries, such as the Saturday Evening Girls, originally began as "clubs" to teach young immigrant women a useful vocational skill.

Giant industrial and craft expositions held in Europe, Britain, and America also propelled the Art Pottery Movement. These events allowed manufacturers of all stripes to show off their finest products,

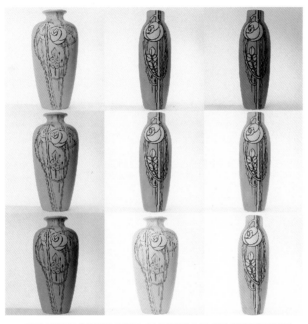

THE ABSTRACT ROSE MOTIF, AN EXAMPLE OF THE INTERNATIONAL ROOTS OF ARTS AND CRAFTS, TRAVELED FROM SCOTLAND TO VIENNA TO OHIO AND NEVER LOST ITS POPULARITY.

while visiting individuals, both amateur and professional, were inspired to new aesthetic heights by the sight of prize-winning examples of furniture, textiles, pottery, glassware, and machinery, as well as objects from other disciplines.

Perhaps the most famous of such events was the Great Exposition of 1851 (among the first of its kind) held at the Crystal Palace in London. The most significant for Americans, however, was the 1876 Centennial Exposition in Philadelphia. There, visitors ogled a dizzying array of domestic and international exhibits, all of which had been assembled to encourage American producers to improve their output. This impetus—combined with a growing interest in home decoration, a fad for collecting china of all types, and a fashion for amateur china painting—led to major developments in the art pottery movement.

Time-honored motifs of Native America as well as currents of Art Nouveau and ingredients from other countries—particularly England—also influenced American art pottery. The English pottery industry, long established in Staffordshire and the Midlands, had been one of the engines of the Industrial Revolution. Many potters trained in England left for the United States to seek their fortunes, among them Charles Fergus Binns and Frederick Hurten Rhead, both of whom worked at American potteries and taught students. There were also strong Austrian and Scottish influences on the decoration of pots, notably from the work of architects and designers Charles Rennie Mackintosh of Glasgow and Josef Hoffmann of Vienna.

In the United States, the firms of Rookwood and Grueby created signature styles which were often imitated by other manufacturers. Rookwood, a Cincinnati firm, dazzled the public with its impressive variety of forms and glazes, both shiny and matte, which garnered prizes in international competitions. Grueby, based in Boston, was famous for its thick, rich, matte glazes that appear velvety to the eye, as well as for its organic motifs, such as leaves and flowers, applied to vases, bowls, and lamp bases hand-made and very often hand-modeled by female art students.

Grueby's popularity was advanced in part by Gustav Stickley, one of the leading figures in American Arts and Crafts. Nurtured by the doctrines of Morris,

Stickley educated the American public to the Arts and Crafts aesthetic not only through his furniture and decorative arts lines but also through *The Craftsman,* his magazine. Of Grueby's matte glazes and organic forms, Stickley declared, they "captured precisely the quiet mood sought."

The area around Zanesville, Ohio, was the home to many commercial potteries inspired to experiment with art lines. These included Weller, Roseville, and Owens. Several important figures were employed at these factories, including Rhead and William Long, an American who went on to found the Denver Pottery and the Clifton Art Pottery. The wares produced by more commercially oriented factories, which tended to rely on mass-production techniques more than the smaller potteries, are not unique, yet they helped to spread the popularity of the movement and made examples available to those of moderate income.

Other Midwestern firms include the Overbeck Pottery, founded by the Overbeck sisters in Cambridge City, Indiana. Overbeck is characterized by simple shapes decorated with intricate, incised designs and pastel matte glazes.

The Gates Pottery, based near Chicago, Illinois, is best known for its Teco ware (short for terra cotta) and connections with the Prairie School architects, such as Frank Lloyd Wright and George Grant Elmslie. Gates began producing the Teco line in 1902. Teco ware is characterized by large architectural shapes, often ornamented with applied abstract leaf and flower forms, as well as by a distinctive Teco green glaze, lighter in tone than Grueby green, with deep gray crystallization that emphasizes the forms of the vases, jardinieres, and lamp bases produced by the pottery. Not hand-crafted, but molded instead, these pieces are nonetheless highly desirable for their fundamentally beautiful designs.

The Arts and Crafts phase of the art pottery movement came to an end by the first years of World War I, overtaken in popularity by Art Deco and early Modernism, as well as popular interest in Colonial reproductions and "quaint" antiques. The spirit of Arts and Crafts lingered on, however, and many potteries continued to produce wares of this ilk well into the 1930s—a boon to contemporary collectors who reap the benefits of this legacy.

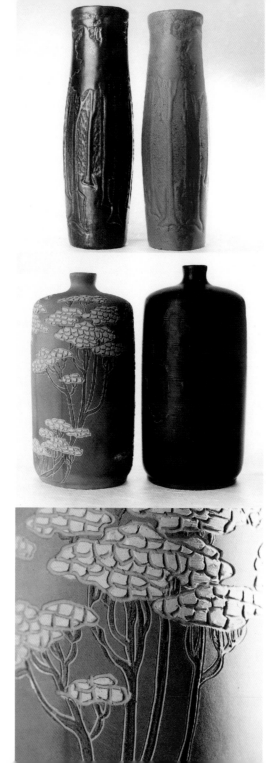

ONE OF ART POTTERY'S GREAT unsolved mysteries is how Charles Walter Clewell developed his technique for covering a fine earthenware form with Ohio potteries—including Weller and Owens—and then applied his own decoration to each piece.

In another instance of cross-fertilization of design

THE POTTER'S QUEST

thin layers of copper, silver, or bronze. (The vase at top right illustrates this technique. The one beside it is identical in every way, except it is not treated by the secret process. Both are from Owens Pottery.) The idea itself was not new or unique to Clewell, but his method was the first to cover completely the body of a pot. Eventually this enterprising artisan was able to create the illusion of hand-hammered metal, as well as rivets, on a single piece. Clewell was also adept at creating a variety of patinas on the metal, particularly a bluegreen patina on bronze and a matte green oxidation on copper. This Arts and Crafts entrepreneur seems to have bought "blanks" from various ideas, a technique called *sgraffito* derived from the Italian *grafitto*, which refers to scratching through the top layer of clay to reveal what lies beneath was brought to the United States by potters trained in England, among them Frederick Hurten Rhead, who served as design director at several potteries in the Zanesville, Ohio, area. The trees incised into the vases shown at middle and in detail at bottom—dating from 1903 to 1905—resemble a typical Rhead motif, although there is no record of his having ever worked for Owens. As Clewell's use of forms bought from other potteries illustrates, many of the commercial potteries were not above appropriating the work of others.

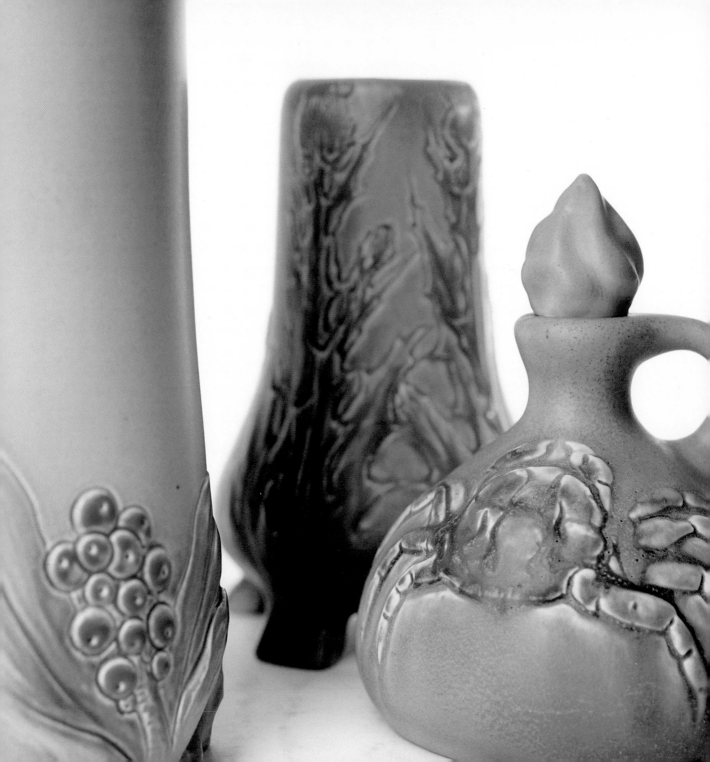

FROM AN ARTIST'S HANDS

DEMANDING A HIGH LEVEL OF SKILL, ROOKWOOD'S LINE OF Modeled Matte showcased the talents of its decorators, who became significant creative forces at the company. The technique involved applying additional clay to an already-formed vessel to create a particular motif, as these lamp bases decorated by Kataro Shirayamadani and jug decorated by Rose Fechheimer so beautifully illustrate.

Rookwood was founded in 1880 by Maria Longworth Nichols, a wealthy Cincinnati matron, who named it for her family estate. Though the company began with underglaze painted decoration—avidly imitated by other potteries, particularly those in the Zanesville area—it soon moved ahead of its imitators, introducing other popular glazes and techniques. The matte glazes were originally proposed by Artus Van Briggle, who was a Rookwood employee before going on to found his own pottery in Colorado. He had probably first seen the matte glazes when studying in Paris in the mid-1890s. They were used for both painted decoration and to adorn molded and incised decoration, another departure from Rookwood's Standard ware.

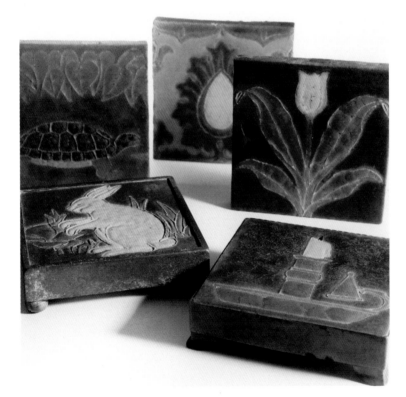

SMALL WONDERS

PRIZED FOR THEIR TWO-DIMENSIONAL designs, intriguing textures, and matte finishes, Grueby tiles are small masterpieces. The matte finish technique popularized a distinctive method of decorating tiles, which had previously been shiny and modeled in relief. Addison B. LeBoutillier, Grueby's second designer, was involved more in the design of tiles than of vases and produced many innovative examples. The tiles were molded first, then decorated by hand, as with these six-inch-square examples dating from circa 1902 to 1909. The inlaid effect was produced by the mold, which left thin ridges of slip (liquid clay) defining the motif. These areas acted as reservoirs to contain the different glazes and keep them separate. The company continued to produce tiles after art pottery production had folded.

Weller
XENIA

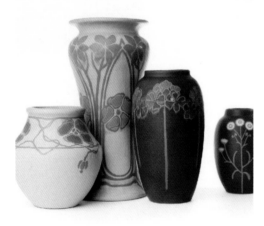

CHARMING NATIVE AMERICAN WILDFLOWERS trail across these Weller vases, known to collectors as Xenia, but strictly having no formal name. The designs are created by inlaying, in which the top layer of clay is removed and filled in with other colors of slip, requiring a great deal of handwork.

Typical of the Weller tendency to copy the work of other pottery makers, these vases (circa 1905 to 1910) bear a resemblance to the designs of Frederick Walrath, Marblehead Pottery, and Rookwood's Matte lines, although they cannot be traced to directly to any of these. It was unusual, however, for a commercial pottery to produce a line that required so much expensive handwork, since the bottom line always had to be a consideration.

ROOKWOOD DECORATORS ALWAYS HAD A fondness for flowers. Asian-influenced wisteria and iris first appeared on the pottery's Standard ware. But later these forms gave way to bouquets of roses and poppies when the company introduced its line of Painted Matte, a difficult and time-consuming technique. The background was sprayed onto biscuit fired ware, using colored slip and an atomizer. Once this coating was dry, the decorator outlined the design, then cut through the top layer and removed the slip from within the outlines. Then glazes of different colors were inlaid in those areas where the background had been removed. One example of relatively rare Painted Matte is the circa-1905 vase (far right) with a wild-rose motif.

Another of Rookwood's fine lines was Decorated Matte. This involved carving and incising motifs before the pottery was glazed—a challenging process, since the heavy matte glazes had a tendency to "crawl" when fired, which would ruin the effect. Still another line, Conventional Matte, is characterized by decorations in solid colors that are outlined in black in a manner reminiscent of many of the book illustrations of the period.

Rookwood also innovated with Vellum, which debuted at the Louisiana Purchase Exposition in St. Louis in 1904. A translucent matte glaze, Vellum allowed Rookwood decorators to employ their preferred method of underglaze decoration, with the addition of a fashionable soft, matte finish. The poppy-motif vase at center is one exquisite example.

POPPIES AND ROSES

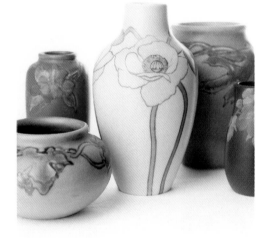

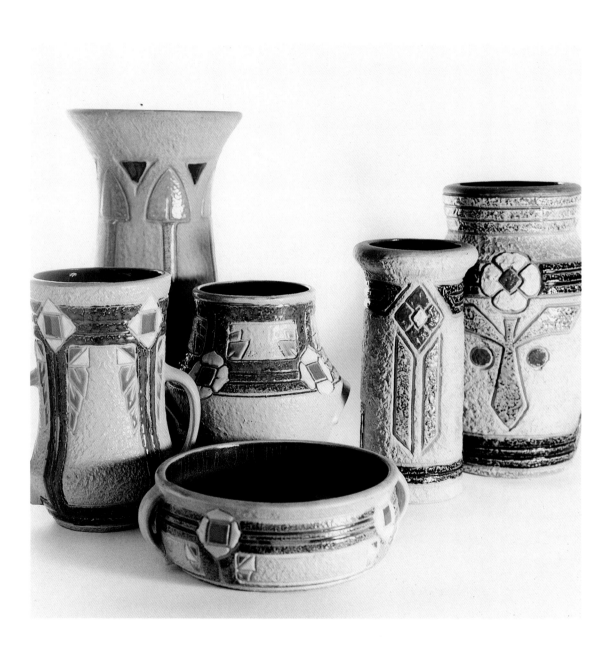

WITH ITS EVOCATIVE, EXOTIC-SOUNDING
name, the Mostique line proved very popular
for Roseville. One of its most common—

ROSEVILLE
MOSTIQUE

and delightful—motifs is the arrowhead, vis-
ible here on the tall vase. Although Frede-
rick Hurten Rhead had left his position as
Roseville's design director in 1908—several
years before this 1915 line was produced—
his influence lingers on in the incised and
carved designs and pebbly matte or unglazed
backgrounds. The motifs appear almost as
though they have been inlaid.

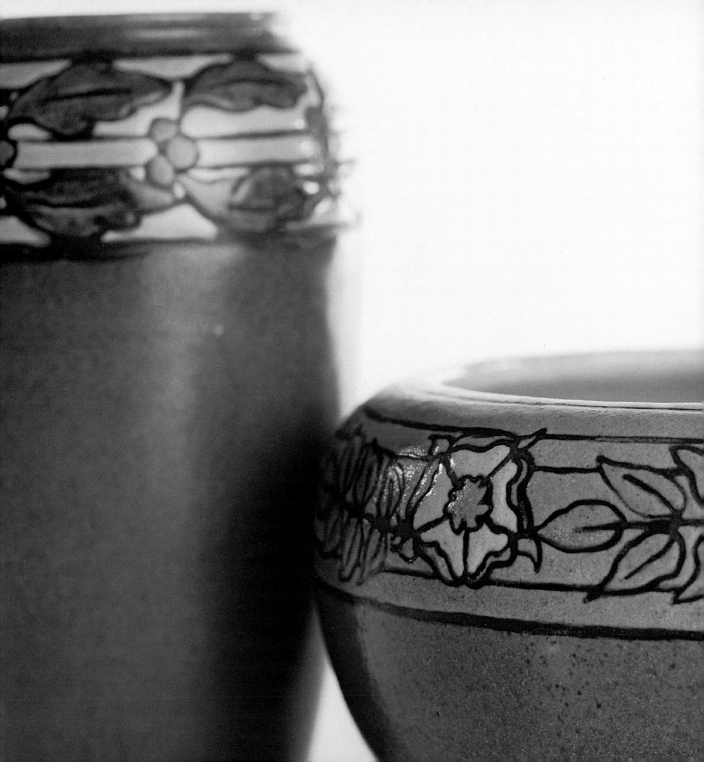

ON SATURDAY NIGHTS IN BOSTON IN the early years of this century, young immigrant women would meet for a few hours of reading and crafts. Out of this activity club came the famous Saturday

SATURDAY EVENING GIRLS

Evening Girls (known affectionately among collectors as "SEG" after the pottery's mark), which, in turn, later became known as Paul Revere Pottery.

In 1906, the parent organization bought a kiln and hired a ceramicist to teach glaze formulas. The pottery grew rapidly and steadily but was not self-supporting. Undaunted, in 1908 the group moved to larger quarters. Young women straight out of school were trained for a year to learn to decorate pots through incising designs and applying colors. After 1915, the pottery moved again to the suburb of Brighton, Massachusetts, and production expanded to include dinner services, breakfast and tea sets, paperweights, inkwells, and bookends. The distinctive "illustrational" style—reminiscent of then-popular book illustration—features incised designs outlined in black and filled in with matte colors. Similar designs appear with the Paul Revere mark.

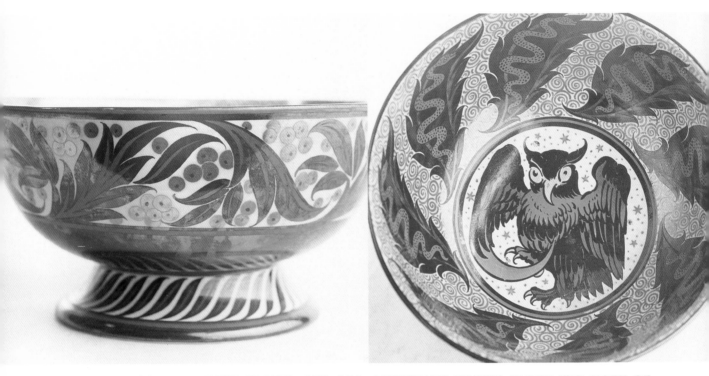

LUSH COLOR, LUSTER GLAZES, AND ODD, LUXURIANT MOTIFS ADORN THE WORK OF William De Morgan. A highly individual and flamboyant designer, De Morgan worked for William Morris when Morris and Co. was first established, but far preferred to remain self-employed and independent. Though his first design undertakings were in stained glass, he began to decorate tiles and pottery in the 1870s. There he found his true calling, as illustrated by the exuberant circa-1890 ruby-luster footed bowl with its imaginative owl motif inside (above).

Luster glazes were also a specialty of the Pilkington Royal Lancastrian Tile and Pottery Co., established in Clifton Junction near Manchester in 1892 by the Pilkington

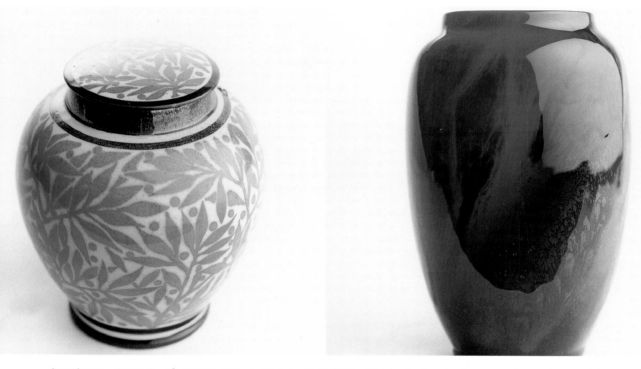

brothers, owners of glasshouses and coal mines. Their first mission was to make archi-
tectural and decorative tiles, but in 1903 the factory began producing decorative vases
with richly colored luster glazes, often in patterns reminiscent of William Morris's
designs for fabric and wallpaper. The circa-1906 tricolored jar above—with pink, black,
and yellow luster—is a charming example.

 Equally beautiful, Royal Doulton's flambé glaze resulted from the strong English
interest in the revival of Chinese glazes, which did not become popular in the United
States until some years later. The sang-de-boeuf vase at right, dating from circa 1906,
shows off the technique.

CLASSIC SHAPES BASED ON
the pottery of ancient Greece
and the Orient distinguish the
work of the famed Fulper
Pottery of Flemington, New

VASEKRAFT

Jersey. To these simple shapes,
potters applied technically
superb matte, crystalline, and
flambé glazes—as with these
statuesque circa-1915 exam-
ples from the Vasekraft line.
The unpredictability of the
crystalline and flambé glazes
meant that these vases were
as unique as hand-decorated
wares—and available at a
lower cost.

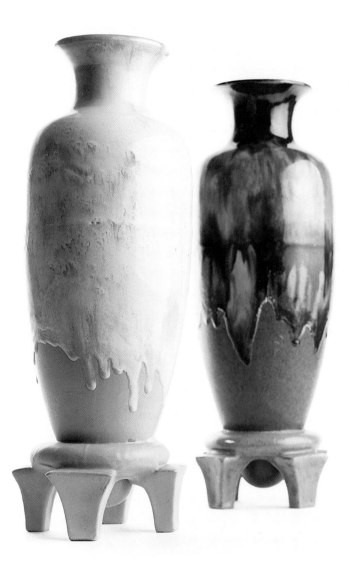

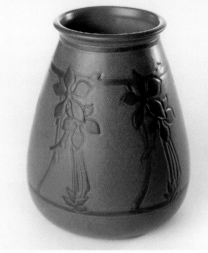

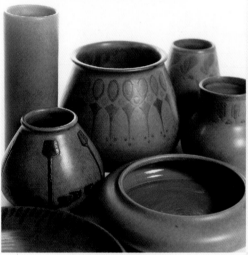

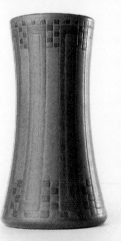
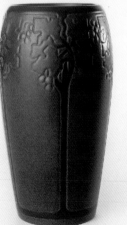

WHEN DR. HERBERT HALL FOUNDED MARBLEHEAD IN THE
Boston area, his admirable intention was to give "nervously worn out
patients . . . the blessing and privilege of quiet manual work, where
as apprentices they could learn again gradually and without haste to
use their hand and brain in a normal, wholesome way." Such was the

MARBLEHEAD

setting in which convalescents sought rehabilitation through pottery,
hand-weaving, wood-carving, and metalwork. Pottery, however, had to
be separated from the medical plan because it proved too difficult for
patients to master in the relatively brief time they were involved in
being educated through the program.

In 1907, after much experimentation, the pottery came into its
own. Arthur Baggs, a student of the Englishman Charles Fergus Binns,
was the head designer. Marblehead is known for simple, well-designed
shapes, severely conventional decoration, and matte glazes in green,
gray, brown, blue, and yellow. All pieces were hand-thrown and deco-
rated. Customers were allowed to choose the most popular designs by
number from a catalog. They selected the background color, and the
decorators worked out the overall color combination. The most com-
mon color was a simple dark blue matte. Medium to dark green was a
less common choice and is considered more attractive by collectors.
A brown glaze is the most rare and desirable.

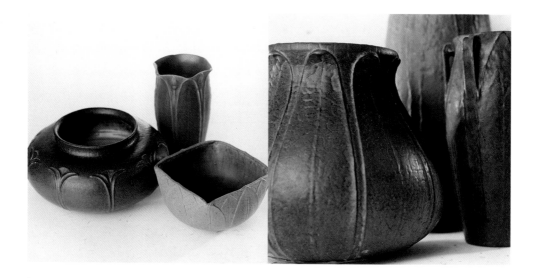

ONE OF A KIND

WILDLY SUCCESSFUL, GRUEBY'S RICHLY FLOWING MATTE GLAZES satisfied an apparently deep-seated longing among collectors for organic, vegetal forms. "This peculiar texture can be compared to the smooth surface of a melon or the bloom of a leaf," a 1904 Grueby sales brochure read poetically, using language that was typical of such paeans.

It all began with William Grueby, who first worked at Low Art Tile Works in Chelsea, Massachusetts. In 1890, he left to establish his own business, moving to Revere, another suburb of Boston, to make architectural ceramic products. This company failed. In 1894, it reappeared as the Grueby Faience Co., which continued to produce terra-cotta architectural ornament, used to adorn many buildings of the late Victorian period.

At the same time, however, Grueby began to experiment with pottery forms and glazes. In 1897, he decided to begin making art pottery and formally incorporated his firm, acquiring two partners, architect William H. Graves, the business manager, and George P. Kendrick, a noted silversmith who served as designer of the early range of vases, lamp bases, and bowls. Grueby was thus freed to experiment with the development of a line of matte glazes. His matte green glaze, in particular, won many prizes at major exhibitions; other colors included blue, yellow, and pink.

In 1899, the firm established a special art pottery division, where the hand-thrown pieces were decorated by female graduates of Boston-area art schools. As a result, each piece of Grueby ware is entirely unique.

Weller by Frederick Rhead

AS HE WAS SELLING FLOWER-
pots door to door, Samuel
Weller probably could not have
dreamed that his humble busi-
ness, which opened in 1873 to
make utilitarian ware, would
one day produce art pottery so
coveted by collectors. Weller
began making his first art ware
in 1893. Frederick Rhead was
hired as a designer in 1904,
although he left to work for
Roseville later that same year.
Trees with "bubble" leaves are

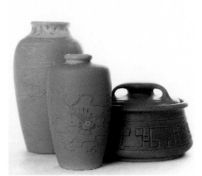

a typical Rhead motif, as on these circa-1904 vases. Signed by Rhead himself, the covered jar—gorgeously decorated with veined rose glaze—was intended for use as a tobacco humidor. A sponge inside the lid kept tobacco from drying out. The motif that is shown on the jar is derived from an authenic Native American pattern and, with a different finish, is known as Suevo. (See page 42, Indian Ware, for an example).

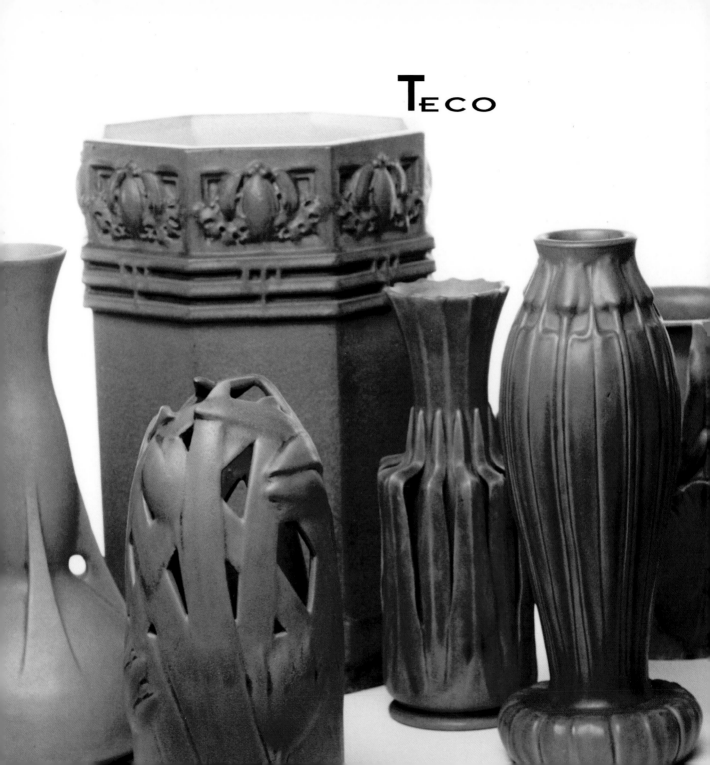

TECO

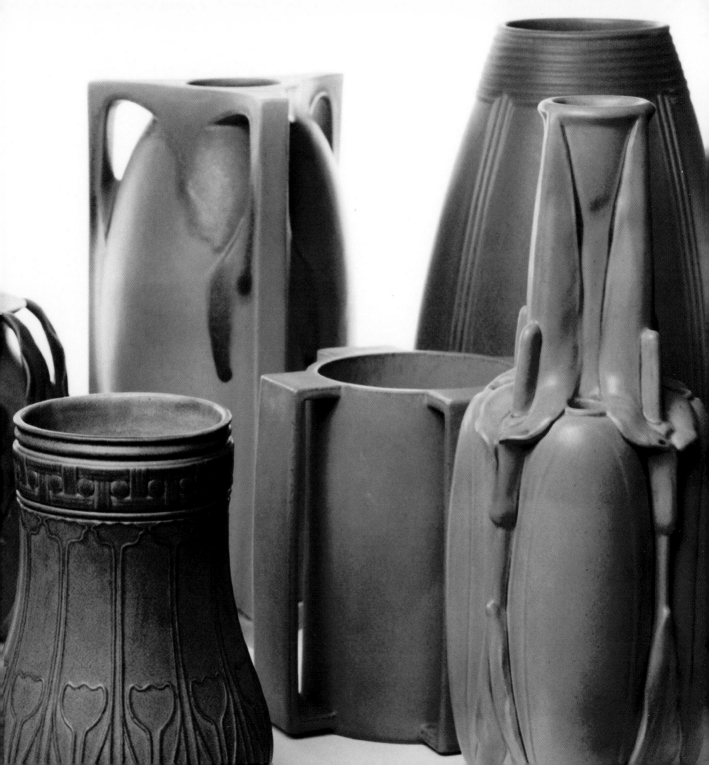

TECO

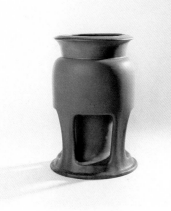

ORGANIC, ARCHITECTURAL, VEGE-
tal: Such adjectives have been
used to describe the stylish
forms of Teco ware—many creat-
ed by Prairie School architects,
including Frank Lloyd Wright him-
self—invited by founder William
Day Gates to contribute their
designs. The wonderful examples
on these pages date from 1901
to 1922 and range in form from
an impressive earthenware sand
urn—possibly designed by George Grant Elmslie or Louis Sullivan
(opposite, bottom left)—to jardinieres and vases with meticulously
applied leaves and flowers (opposite, top right).

Connoisseurs seek deep hues and glaze pools, which create
crystalline gray tones that emphasize the fine designs. Teco ware
was intended to supply art pottery at a price those of moderate
income could afford, as stated in a sales brochure: "In Teco Art
Pottery the constant aim has been to produce an art pottery having
originality and true artistic merit, at a comparatively slight cost, and
thus make it possible for every lover of art pottery to number among
his treasures one or more pieces of this exquisite ware."

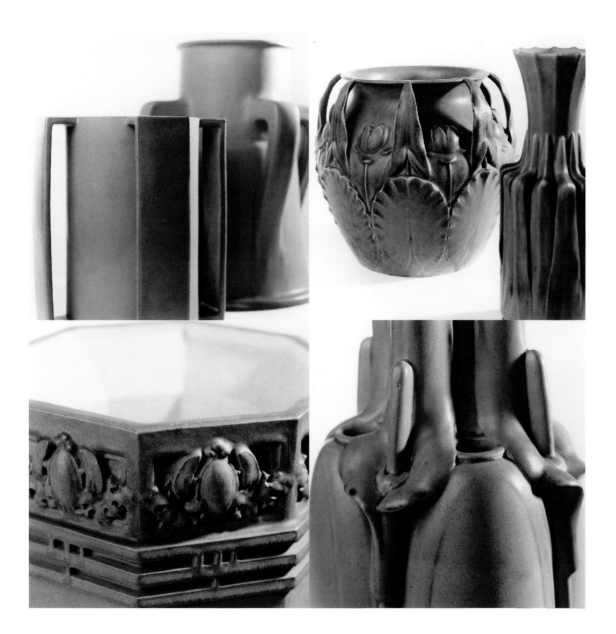

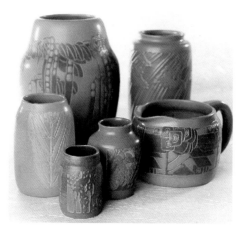

IMAGES OF CLOUDS AND RAIN, SEED-pods, trees, and roses—influenced by sources as diverse as Scots architect Charles Rennie Mackintosh and Viennese design—pepper the work of Overbeck Pottery. In production from 1911 to 1915, the pottery was the work of three sisters, Elizabeth, Hannah, and Mary Frances Overbeck, in Cambridge City, Indiana. The fourth and oldest sister, Margaret, was trained in art and worked as a decorator at

A TALE OF FOUR SISTERS

Zanesville Art Pottery but died in 1911. Elizabeth had studied ceramics with Charles Fergus Binns in Alfred, New York, at the New York State School of Ceramics, while Mary Frances had studied art at Columbia University in New York City, as had Margaret. The sisters, trained to be teachers, instead chose to earn a living by running an art pottery studio, doing all but the heaviest work themselves. One sister—usually Elizabeth—would design the pot, while a second—most often Hannah or Mary Frances—would decorate it. The strong graphic influence and rectilinear designs show that even in Indiana potters were well aware of international design trends.

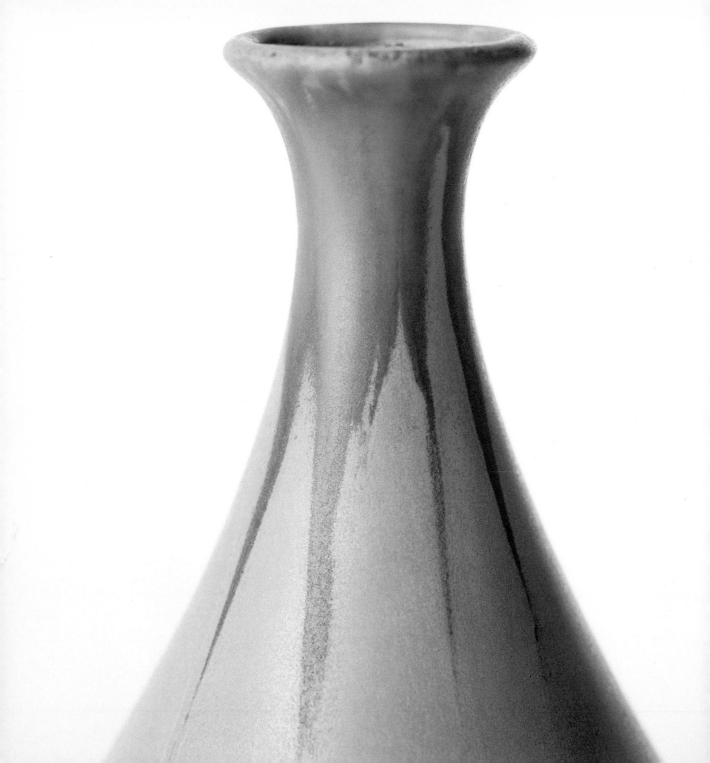

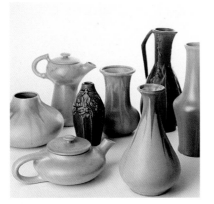

REPRESENTING THE TRANSITION from painted to glazed decoration in Arts and Crafts art ware, these simple vessels—all dating from 1905 to 1909—come from the hand of William Long. An especially intriguing figure, Long had the ability to reinvent himself with each new job. Indeed, it is an amazing fact that these different styles could all be designed by one person within a few short years.

DENAURA AND CRYSTAL PATINA

After having worked in Ohio at various potteries, including Weller (where he developed Lonhuda, similar to Rookwood Standard ware), Long moved westward and organized the Denver China and Pottery Co. in 1901. Two years later, he introduced Denaura, incorporating designs of native Colorado flowers and various glazes. The most common glaze was matte green, which in the words of pottery historian Paul Evans, "swept over the art pottery world in the wake of the Grueby success." Examples above are the small vase behind the teapot and the handled pitcher.

All the other objects depicted are called Crystal Patina, developed by Long in his next incarnation at the Clifton Art Pottery in Newark, New Jersey. This line is distinguished by a crystalline glaze in pale green or blue (robin's egg). The name comes from crystallization of the glaze and the suggestion of green oxidation, like the patina on bronze. To read about another life of Long, simply turn the page.

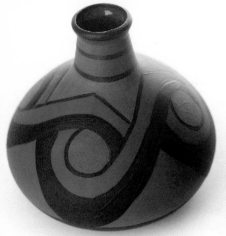

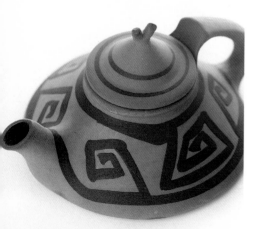

INDIAN WARE BY CLIFTON, WELLER, OWENS

THOUGH IT COULD EASILY BE sold in a gift shop on a Native American reservation (some say it really was), Indian Ware was actually the creation of William Long— the protean designer who was never at a loss for new ideas. The pottery was made from native New Jersey clay and inspired by American Indian forms.

Similar lines were produced by Weller (as with the Suevo floor vase shown at right and in detail below) and Owens (whose Aborigine jardiniere is shown at top left). However, Clifton was the first to produce such designs (examples are the Arkansas vase, second from top left; teapot, bottom left; and Little Colorado vase, top right). These were incised with Native American designs, often inspired by specific tribes. The vessels were left unglazed on the exterior in imitation of authentic Native American pieces, but were glazed on the interior, making them waterproof.

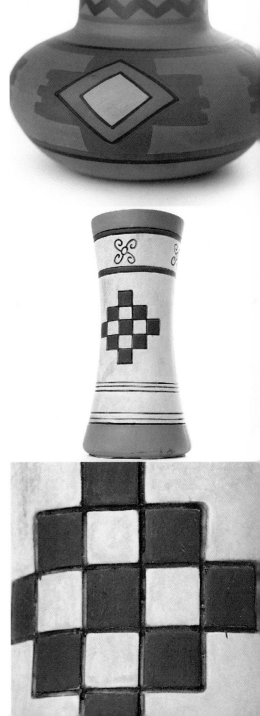

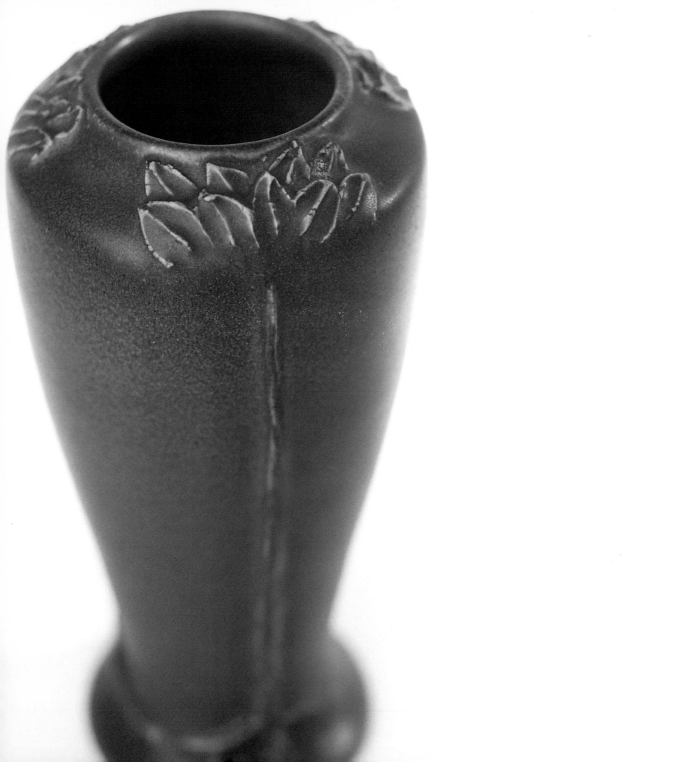

Rookwood
hand thrown

COVERED WITH A MATTE GLAZE
that resembles old metal, this Rook-
wood vase is simple and stylized—the
polar opposite of the company's Stan-
dard ware, with underglaze painting
and bravura glazes. The two markedly
different styles testify to the pottery's
originality of design.

Splendid Stoneware

ORIGINALLY DECO-
rated by art students, the
Doulton's stoneware
line is imbued with a
certain fresh whimsy. In
the 1860s, the firm—
which had its factory
and workshops in the
South London borough
of Lambeth—set up
a collaboration with
students at the Lambeth
School of Art. Doulton
supplied the equipment
and the turned and thrown
pots, while the students
supplied the ornamental
touches. The line proved
popular enough to be
incorporated into the
company's standard pro-
duction. These examples
date from circa 1925.

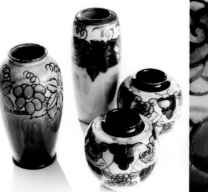

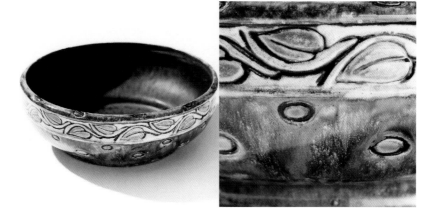

OWENS AQUA VERDE

WITH NAMES LIKE FEROZA AND AQUA Verde, Owens vases evoke the romance of Italy, but were actually produced in the American Midwest. Another of the important Zanesville potteries, Owens, was founded by J.B. Owens in 1891. It produced good quality art pottery which was made there from approximately 1896 to 1907, with each line distinguished by a different glaze. The large matte green vase is of a shape usually used with the Feroza glaze, a gun-metal metallic that resembled burnished metal. The smaller vase is from the Aqua Verde line. Aqua Verde, a slightly iridescent green, was used on vessels with stylized decoration and was probably developed to cash in on the popularity of green glazes. Indeed, throughout his work, Owens produced several distinctive variations on green glazes.

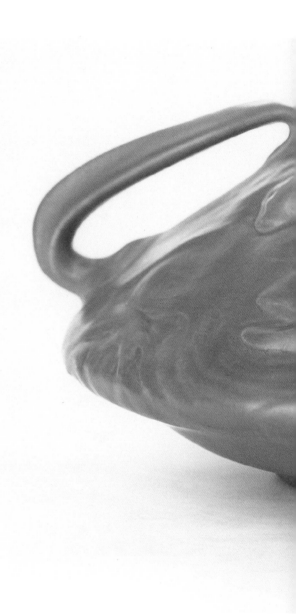

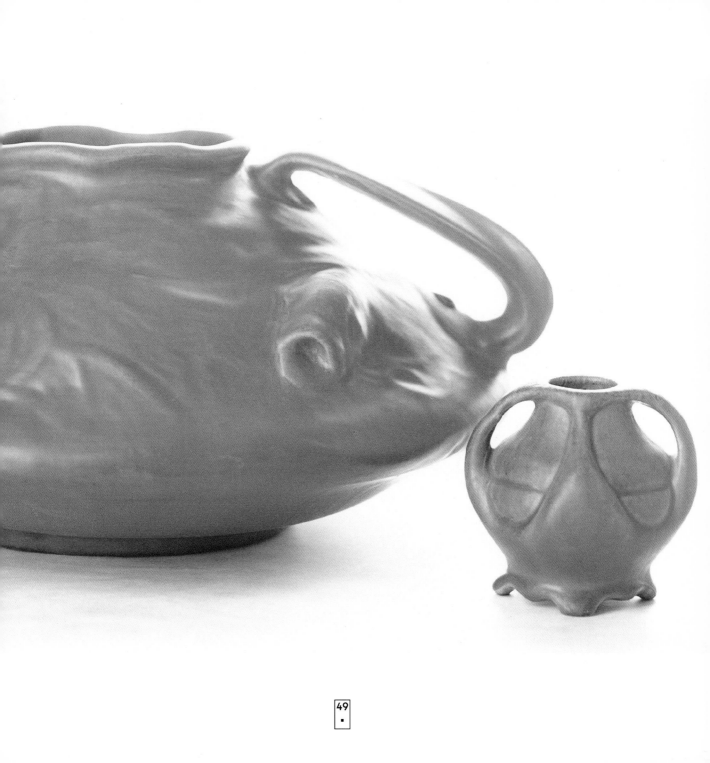

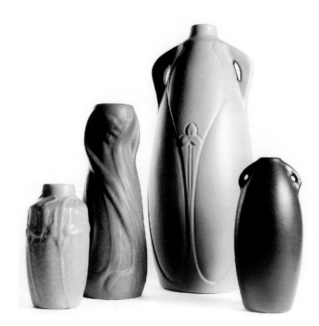

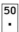

DAZZLED BY ORIENTAL MATTE AND SANG-DE-BOEUF glazes while in Paris on scholarship through Rookwood, Artus Van Briggle earnestly wished to reproduce them. In 1896, he returned to Cincinnati to work at Rookwood as a

VAN BRIGGLE

decorator, but having contracted tuberculosis, resigned in 1899 and had moved to Colorado by 1901.

There, he established a small studio in Colorado Springs and began making vases in an idiosyncratic, rather Art Nouveau-influenced style. Van Briggle's work is unusual in that he used molds to recreate his best work, believing that a uniform production was preferable to individualistic work. The handled ocher and rare black matte vases shown here may have been executed by Van Briggle himself in 1904, the last year of his life. Though he was only in his mid-thirties when he died, Van Briggle contributed much to American art pottery.

DRESSER POTTERY

IMBUED WITH A STRONG, PRIMITIVE, ALMOST GROTESQUE
quality, this jug is typical of the work of Englishman Dr. Christopher
Dresser. Dresser was a significant figure in the Arts and Crafts
Movement; a good friend of the proprietor of Liberty and Co. and an
important designer in his own right. In 1879, he was invited by Henry
Tooth, who had recently opened an art pottery in Linthorpe, to con-
tribute some designs—the result being pieces with similar, unusual shapes.

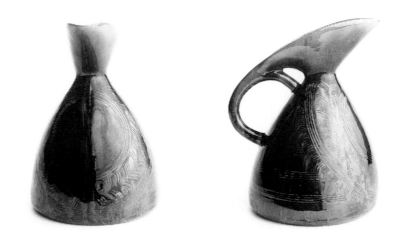

CREAM JUG, DEMITASSE cups, plates, and salt and pepper shakers made a neat table setting at the bustling Roycroft Inn—a mecca for early twentieth-century tourists.

BUFFALO POTTERY

From 1910 to 1925, the Buffalo Pottery produced this service under contract for the inn, and it was not commercially available. The design is by Roycroft stalwart Dard Hunter and features the orb and cross symbol prominently. John Larkin, the founder of Buffalo Pottery, was Elbert Hubbard's brother-in-law and former business partner. Though it sounds peculiar today, Larkin established the pottery in order to provide premiums for the purchase of soap, a highly popular practice at the turn of the century.

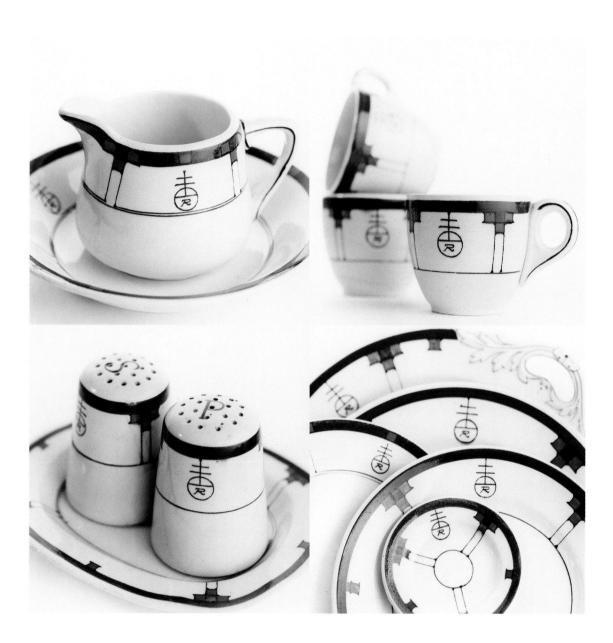

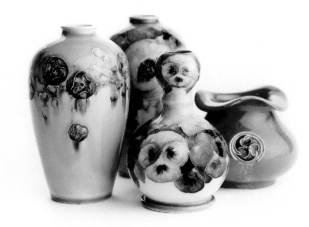

PIPED LIKE ICING

THE "SQUEEZE-BAG" DECO-ration on the delicious pottery made by these two British firms, Moorcroft and Mintons, creates a very delicate tracery of unique charm. These particular Moorcroft pieces (opposite page) are unusual because they were exclusively retailed by Liberty & Co. Just three inches high, the green circa-1905 vase with the fluted lip is a rare form of Flamminian ware. The others, ranging in date from 1902 to 1913, are ornamented with beautiful botanical motifs. These vessels are true art pottery, intended for display and as collectibles, not for truly practical use.

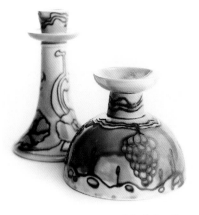

Dating from 1906, the Secession ware by Mintons (this page) was intended to honor Viennese design, invoking the most exciting new design movement of the turn of the century—though these particular examples are more French in terms of inspi-ration, colors, and technique. This was a fairly successful line for Mintons, with molded bodies and hand-applied decoration. The design of the chamberstick is taken from one by Dr. Christopher Dresser. Instead of a handle, the hemi-spherical base contains two holes, big enough for the thumb and forefinger.

HAMPSHIRE POTTERY

THE HAMPSHIRE POTTERY WAS established in 1871 in Keene, New Hampshire, by James S. Taft. Its claim to fame in the Arts and Crafts field comes from being the first to develop a green matte glaze, although this accomplishment has been overshadowed by the success of Grueby. Many products of the Hampshire Pottery resemble Grueby closely, and in fact the pieces are often known as "poor man's Grueby," because the ware was molded rather than hand-thrown and therefore generally much less expensive.

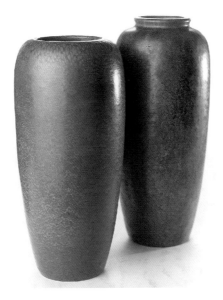

Sources

Arts and Crafts Emporium
434 North La Brea Ave.
Los Angeles, CA 90036
213/935-3777

ASG Antiques
Rt. 2, Box 66
Berkley Springs, WV 25411
304/258-4037

Robert Berman Antiques
441 South Jackson St.
Media, PA 19063
215/843-1516
By appointment only

Cherry Tree Antiques
125 East Rose
Webster Groves, MO 63119
314/968-0700

Coles Collectibles
P.O. Box 174
Martin, GA 30557
404/779-3712

Dalton's American Decorative Arts
1931 James St.
Syracuse, NY 13206
315/463-1568

Duke Gallery
312 West 4th St.
Washington Square Plaza
Royal Oak, MI 48067
313/547-3377

Philip Gabe Arts & Crafts
603 Grant St.
Iowa City, IA 52240
319/354-3377

Raymond Groll
P.O. Box 421
Station A
Flushing, NY 11358
718/463-0059

JMW Gallery
144 Lincoln St.
Boston, MA 02111
617/338-9097

Kurland·Zabar
19 East 71st Street (Madison Ave.)
New York, N.Y. 10021
(212) 517-8576
Specializing in 19th and 20th
century decorative arts

McCormack & Co.
1215 Woods Circle NE
Atlanta, GA 30324
404/266-8411

Mission Oak Shop
109 Main St.
Putnam, CT 06260
203/928-6662

David Rago Arts & Crafts
9 South Main St.
Lambertville, NJ 08530
609/397-9374

Split Personality
223 Glenwood Ave.
Leonia, NJ 07605
201/947-1535
Specializing in English Arts & Crafts

Don Treadway
2128 Madison Rd.
Cincinnati, OH 45208
513/321-6742

Twentieth Century Consortium
1911 West 45th St.
Kansas City, KS 66103
913/362-8177

Woodsbridge Antiques
P.O. Box 239
Yonkers, NY 10705
914/963-7671

AUCTION HOUSES

Christie's
502 Park Ave.
New York, NY 10022
212/546-1000

Christie's East
219 East 67th St.
New York, NY 10021
212/606-0400

Fontaine's Auction Gallery
173 S. Mountain Rd.
Pittsfield, MA 01201
413/448-8922

David Rago
American Arts & Crafts Auctions
17 S. Main St.
Lambertville, NJ 08530
609/397-9374
Specializing in the sale of Arts and
Crafts objects at auction

Savoia's Auction, Inc.
Route 23
South Cairo, NY 12482
518/622-8000

Skinner, Inc.
2 Newbury St.
Boston, MA 02116
617/236-1700

Sotheby's
1334 York Ave.
New York, NY 10021
212/606-7000

Don Treadway
2128 Madison Rd.
Cincinnati, OH 45208
513/321-6742

HOUSES TO VISIT

Craftsman Farms
2352 Rte. 10 West (Parsippany)
Box 5
Morris Plains, N.J. 07950
201/540-1165

The Gamble House
4 Westmoreland Pl.
Pasadena, CA 91103
818/793-3334

Grove Park Inn
290 Macon Ave.
Asheville, NC 28804
800/438-5800

Roycroft Campus
South Grove St.
East Aurora, NY 14052
Original buildings (not all open to the
public) and shops specializing in Arts
& Crafts items.

Frank Lloyd Wright Home and Studio
951 Chicago Ave.
Oak Park, IL 60302
708/848-1976

CONFERENCES AND SHOWS

Arts and Crafts Quarterly Symposium
c/o The Arts and Crafts Quarterly,
609/397-4104
Annual conference held at Craftsman
Farms in August; includes seminars,
exhibits, and antiques show.

Grove Park Inn Arts & Crafts
Conference and Antiques Show
Asheville, N.C.
800/438-5800
Annual conference held at Grove Park
Inn, third week in February; includes
seminars, tours, and antiques show.

Annual Arts and Crafts Period
Exposition and Sale
Metropolitan Antiques Pavilion
110 W. 19th St.
New York, NY 10011
212/463-0200
Held in May.

American Art Pottery Association
Convention
Contact Jean Oberkirsch, AAPA
Secretary/Treasurer, 125 E. Rose, St.
Louis, MO 63119 or consult AAPA
Journal (see below, right) for more
information. Held in June.

Pottery Lovers Reunion
Holiday Inn
Zanesville, Ohio
Check specialty publications for infor-
mation on exact dates and times.
Held in July.

For information on a variety of
twentieth-century antiques shows
in the Northeast contact:
Sanford L. Smith & Associates
68 East 7th St.
New York, NY 10003
212/777-5218

PUBLICATIONS

The American Bungalow
123 S. Baldwin, P.O. Box 756
Sierra Madre, CA 91025
800/350-3363
6 issues/year

Antiques & Fine Arts
255 N. Market St. Suite 120
San Jose, CA 95110
6 issues/year

The Arts & Crafts Quarterly
9 S. Main St.
Lambertville, N.J. 08530
4 issues/year

The Craftsman Homeowner Club
Newsletter
31 S. Grove St.
East Aurora, NY 14052
3 issues/year
(part of club membership)
716/655-0562

The Journal of the American Pottery
Association
Box 210342
San Francisco, CA 94121
6 issues per year
(part of membership)

The Grove Park Inn Show catalogue
contains valuable information on many
aspects of Arts and Crafts collecting. It
is available through Bruce Johnson,
P.O. Box 8773,
Asheville, NC 28814

Grant Elmslie or Louis Sullivan; 15 in. h., 9 1/2 d. Shape 151 (201) vase with pierced leaves; designed by William J. Dodd; 11 in. h., 5 1/2 in. d. Shape 85 vase with applied leaves; designed by William J. Dodd; 13 in. h. Shape 397 lily-motif footed vase; designed by John Lillesham; 13 1/2 in. h. Shape 86 jardiniere with applied tulips and leaves; 9 5/8 in. h., 10 1/2 in. d. Shape 261 vase with buttress handles; designed by B.G. Benedict (rare example); 15 1/2 in. h. Shape 154 bulbous tulip-motif vase; designed by William LeBaron Jenney; 10 in. h., 7 in. d. Shape G500 loving cup/lamp base; 9 in. h., 6 in. d. Shape 252A lamp base; designed by Hugh M.G. Garden; 17 1/2 in. h. Shape 141 calla-lily-motif vase; designed by Fritz Albert; 17 in. h.; all c. 1901-22; Stephen Gray.

P. 36: Teco Shape 171 vase; designed by Jeremiah K. Cady; 13 in. h.; c. 1901-22; Stephen Gray.

P. 37: Teco, top left—Loving cup/lamp base (see description for pp. 34-35). Shape 173 three-handled vase; 13 1/2 in. h., 9 1/2 d.
Top right—Jardiniere (see description for pp. 34-35). Vase with applied leaves (see description for pp. 34-35). Bottom left—Sand urn (see description for pp. 34-35). Bottom right—Calla-lily-motif vase (see description for pp. 34-35); all c. 1901-1922; Stephen Gray.

P. 38: Overbeck, clockwise from top left—Seed-pod-motif vase; 10 in. h. Clouds-and-rain-motif vase; 8 3/4 in. h.. Stylized roses pitcher; 4 3/4 in. h. Pine-cone-motif vase; 4 1/2 in. h. Tree-motif vase; 3 3/4 in. h. Vase with stylized floral form; 6 in. h.; all c. 1915; Stephen Gray.

P. 40: Crystal Patina vase; Clifton; 8 1/2 in. h.; c. 1905-1909 (also shown p. 41); Allan Wunsch.

P. 41: Left to right—Crystal Patina vase; Clifton; 5 in. h.; c. 1905-1909. Crystal Patina teapot; Clifton; 3 3/4 in. h.; c. 1905-1909. Crystal Patina teapot; Clifton; 7 1/2 in. h.; c. 19.5-1909 Denaura vase; Denver; 6 3/4 in. h.; c. 1903. Crystal Patina vase (description for p. 40). Denaura pitcher; Denver; 10 1/4 in. h.; c. 1903. Crystal Patina vase; Clifton; 10 1/4 in. h.; c. 1905-1909; Allan Wunsch.

P. 42: Top to bottom—Aborigine jardiniere; Owens; 7 3/4 in. h., 10 1/4 d.; c. 1903-1908. Arkansas vase; Clifton; 5 in. h.; c. 1905-1907. Aborigine vases; Owens; 8 in. h. and 5 3/4 in. h.; c. 1905-1907. Teapot; Clifton; 9 in. d.; c. 1905-1907; Allan Wunsch.

P. 43: Top to bottom—Little Colorado vase; Clifton; 5 in. h.; c. 1905-1907. Suevo floor vase (and detail below); Weller; 14 3/4 in. h.; c. 1907-10; Allan Wunsch.

P. 44: Shape 1356E Modeled Matte vase; Rookwood; decorated by William Hentschel; 7 1/4 in. h.; 1910; Allan Wunsch.

P. 46: Royal Doulton, left to right—Pair of stoneware vases; each 5 3/4 in. h. (also shown at far right). Stoneware balustrade vase; 9 1/2 in. h. Cylindrical stoneware vase; 10 in. h.; all c. 1925; Kurland-Zabar.

P. 47: Stoneware bowl (both photos); Royal Doulton; 9 3/4 in. d.; c. 1925; Kurland-Zabar.

PP. 48-49: Handled vases; Owens; 5 3/4 in. and 3 in. h.; c. 1907; Allan Wunsch.

P. 50: Van Briggle, left to right—Green vase; 6 1/2 in. h.; 1903. Olive vase; 11 in. h.; 1902. Handled ocher vase; 16 1/2 in. h.; 1904. Black matte vase; 8 in. h.; 1904; Raymond Groll.

P. 53: Jug with green and brown glaze over incised decoration; Linthorpe Art Pottery; designed by Dr. Christopher Dresser; 7 3/4 in. h.; c. 1879-1882; Catherine Kurland.

PP. 54-55: Roycroft dinner service by Buffalo Pottery—Cream jug; 3 1/2 in. h. Demitasse cups; 2 1/2 in. h. Plates; 9 1/2 in. d. Salt and pepper shakers 3 1/2 in. h.; c. 1910-1925; Raymond Groll.

P. 56: Moorcroft (made for Liberty), left to right—Tudor-rose-motif vase; 5 1/4 in. h.; c. 1904. Pomegranate-motif vase; 5 1/4 in. h.; c. 1911-13. Pansy-motif vase; 4 1/2 in. h.; c. 1902-10. Green Flamminian ware; 3 in. h.; c. 1905; Barry R. Harwood.

P. 57: Mintons Secession ware—Candlestick; 6 1/5 in. h. Chamberstick; 4 1/4 in. h.; both 1906; Barry R. Harwood.

P. 59: Blue and green vases; Hampshire Pottery; 11 in. and 11 1/2 in. h.; both c. 1904-1914; Robert Posch.

INDEX

Aqua Verde, 48

arrowhead motif, 21

Art Nouveau influences, 51

Arts and Crafts movement: England, 9-10; United States, 10-11

Baggs, Arthur, 29

Binns, Charles Fergus, 10, 29, 39

Boston, 10, 23, 29

bowls, 24, 30-31, 47

Brighton, Massachusetts, 23

Buffalo Pottery, 54-55

Cambridge City, Indiana, 11, 39

Centennial Exposition of 1876, 10

chamberstick, 57

Chicago, 11, 34-37

Cincinnati, 10, 15, 51

Clewell, Charles Walter, 13

Clifton Art Pottery, 11, 41-43

Clifton Junction, England, 24

cloudandrain motif, 39

Colorado Springs, 51

Conventional Matte, 19

Craftsman, The (magazine), 11

Crystal Patina, 41

Decorated Matte, 19

De Morgan, William, 24

Denaura, 41

Denver China and Pottery Co., 11, 41

dinner service, 54-55

Dresser, Dr. Christopher, 52-53, 57

Elmslie, George Grant, 11, 36

Fechheimer, Rose, 15

Feroza, 48

Flamminian ware, 57

Flemington, New Jersey, 26

Fulper Pottery, 26-27

Gates Pottery, 11, 36

glazes: crystalline, 11, 26-27, 36, 41; flambé, 25-27; luster, 24-25; matte: 10-11, 15, 17, 19, 22-23, 26-31, 45; black, 50-51; green,31, 41, 48, 58-59; ocher, 50-51; pebbly, 21

Graves, William H., 31

Great Exposition of 1851, 10

Grueby, 10-11, 16-17, 30-31, 58

Hall, Dr. Herbert, 29

Hampshire Pottery, 58-59

Hoffmann, Josef, 10

Hubbard, Elbert, 54

Hunter, Dard, 54

incised designs, 13, 21, 23

Indian Ware, 42-43

inlaying technique, 18

jardinieres, 36-37, 43

jars, 25, 32-33

jugs, 14-15, 52-53

Keene, New Hampshire, 58

Kendrick, George P., 31

lamp bases, 14-15

Larkin, John, 54

LeBoutillier, Addison B., 17

Liberty & Co., 57

Linthorpe Art Pottery, 52

London, 10, 46

Long, William, 11, 41, 43

Lonhuda, 41

Louisiana Purchase Exposition, 19

Mackintosh, Charles Rennie, 10, 39

Marblehead Pottery, 18, 28-29

metal overlays, 13

Mintons, 57

Modeled Matte, 15

Moorcroft, 56-57

Morris, William, 9, 24

Mostique, 21

Native American motifs, 10, 18, 32-33, 41-43

Newark, New Jersey, 41

Nichols, Maria Longworth, 15

orbandcross motif, 54-55

organic forms, 11, 30-31, 34-37

organic motifs, 10-11, 15, 19, 22-23, 36, 39, 41, 56-57; roses, 9, 19, 39; trees, 12-13, 32-33, 39

Overbeck Pottery, 11, 39

Owens Pottery, 11, 13, 42-43, 48-49

owl motif, 24

Painted Matte, 19

patinas, 13

Paul Revere Pottery, 22-33

Philadelphia, 10

Pilkington Royal Lancastrian Tile and Pottery Co., 24-25

pitchers, 41

Rhead, Frederick Hurten, 10, 11, 13, 21, 32-33

Rookwood, 10, 14-15, 18-19, 41, 45, 51

Roseville, 11, 21, 32

Royal Doulton, 25, 46-47

Roycroft Inn, 54

Ruskin, John, 9

Saturday Evening Girls, 9, 23

Secession ware, 57

sgraffito technique, 13

Shirayamadani, Kataro, 15

St. Louis, 19

Stickley, Gustav, 10-11

stoneware, 46-47

Suevo, 33, 42

Sullivan, Louis, 36

Taft, James S., 58

teapots, 41, 42-43

Teco ware, 11, 34-37

tiles, 16-17

Tooth, Henry, 52

urns, 3637

Van Briggle, Artus, 15, 50-51

Vasekraft, 26

vases, 9, 12-13, 18-23, 25-46, 48-59

Vellum, 19

Viennese design influences, 39, 57

Walrath, Frederick, 18

Weller, 11, 13, 18, 32-33, 41-43

women artisans, 9-11, 23, 31, 39

Wright, Frank Lloyd, 11, 36

Xenia, 18

Zanesville, Ohio, 11, 13, 41, 48